ED ARNO'S MOST WANTED

BOOKS ILLUSTRATED
BY THE SAME AUTHOR

The Gingerbread Man

The Magic Fish

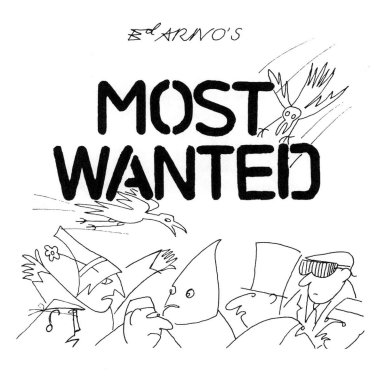

Ed ARNO'S

MOST WANTED

TURTLE POINT PRESS

NEW YORK

TURTLE POINT PRESS

ISBN 1-885983-30-1

Library of Congress Catalog Number: 98-060325

DEDICATION

In memory of my friend Jean Negulesco who encouraged me in 1965 to seek political asylum in The United States and make New York my home.

With deepest appreciation to Saul Steinberg who introduced me to James Garaghty cartoon editor of The New Yorker, Magazine.

My love and admiration to Leila Hadley Luce, an invaluable friend who was the best cartoon editor I ever met. Her enthusiasm inspired me to put this collection of cartoons together. She also introduced me to my publisher Jonathan Rabinowitz who immediately understood the book's plot, laughed out loud and had the guts to publish 'his' first cartoon book.

Ed ARNO/98

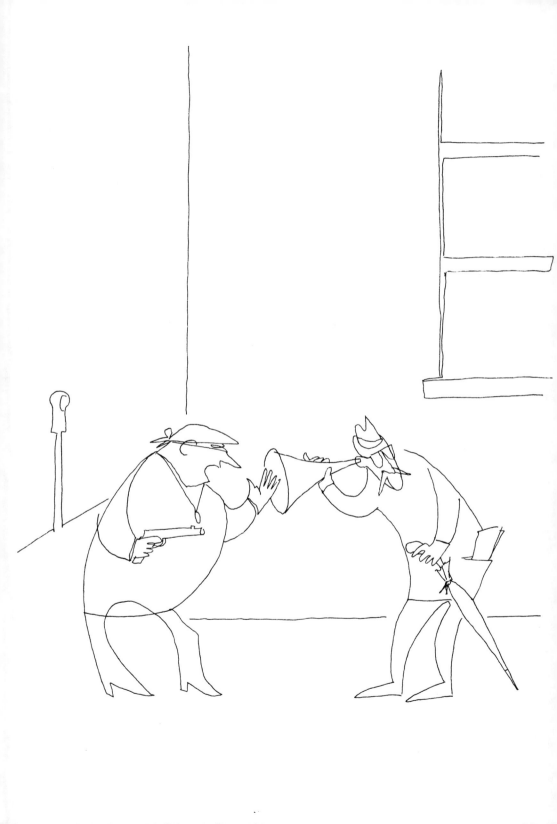

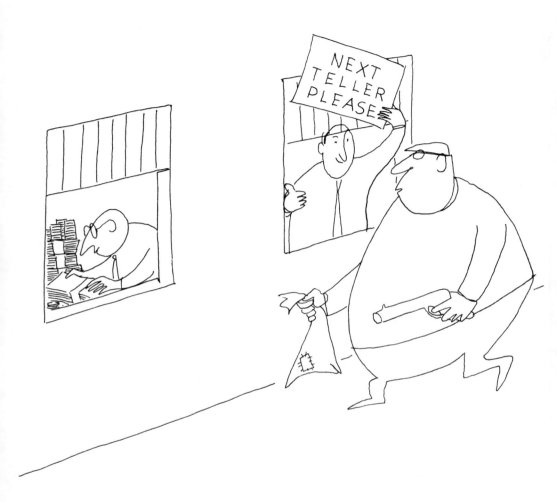

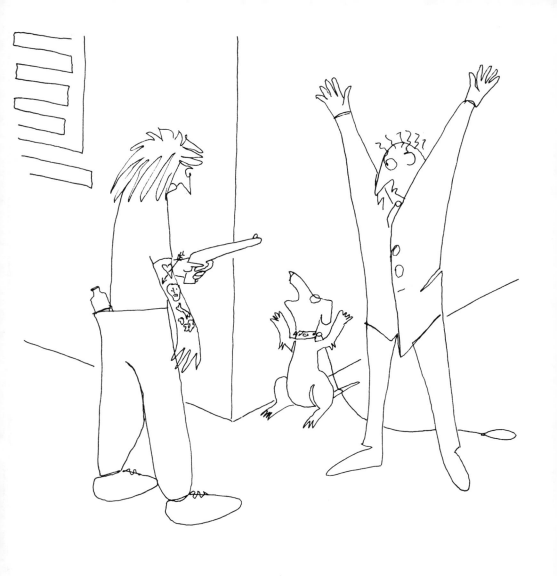

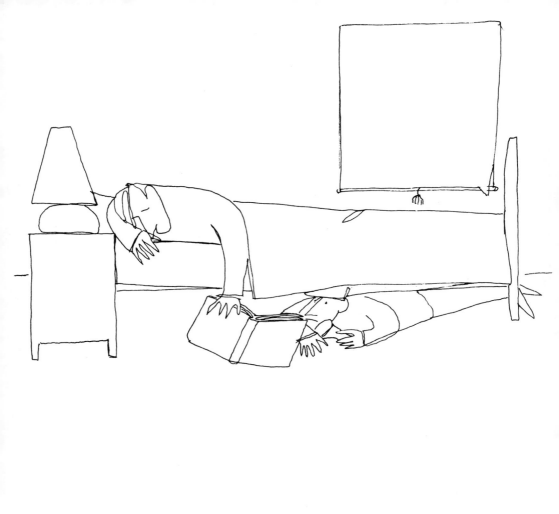

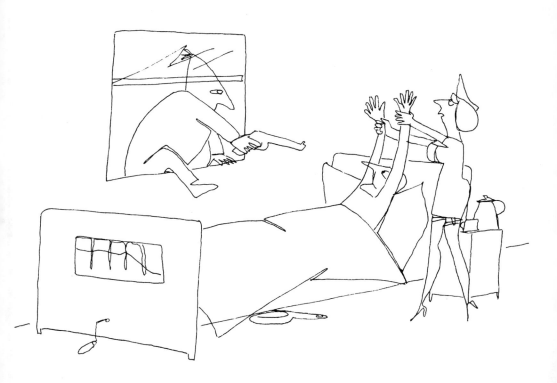

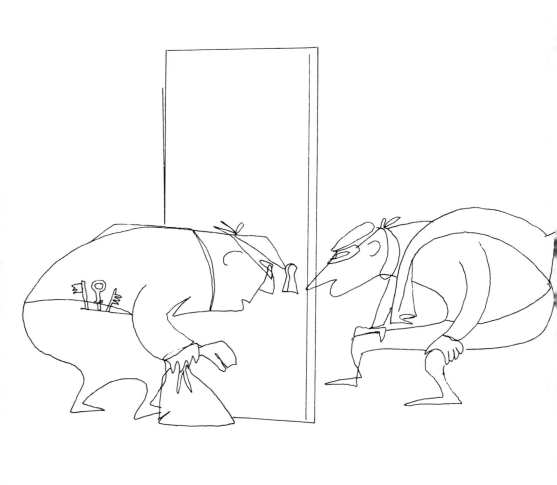

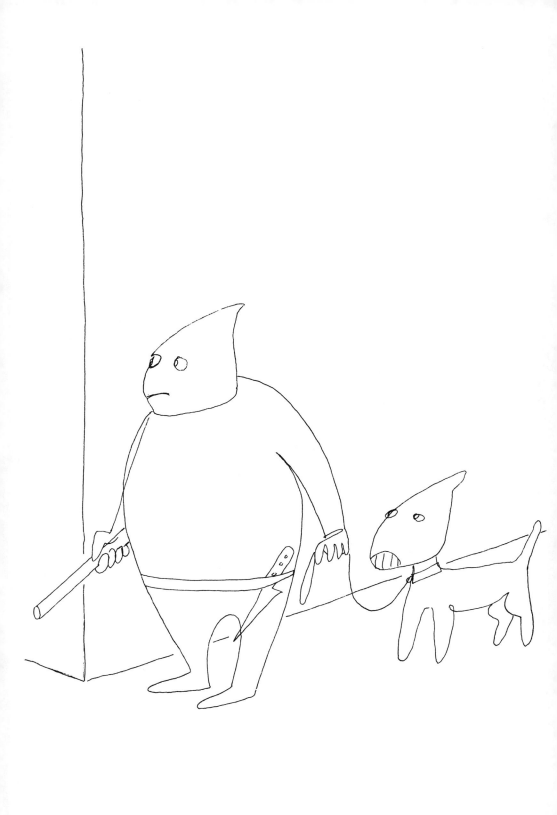

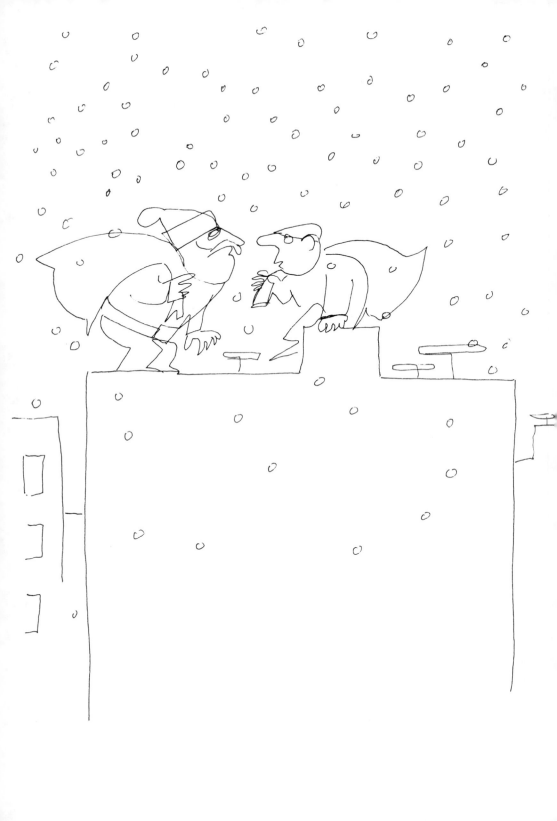

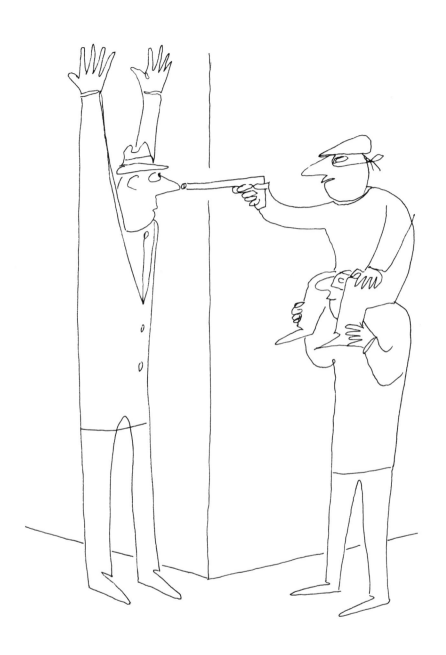

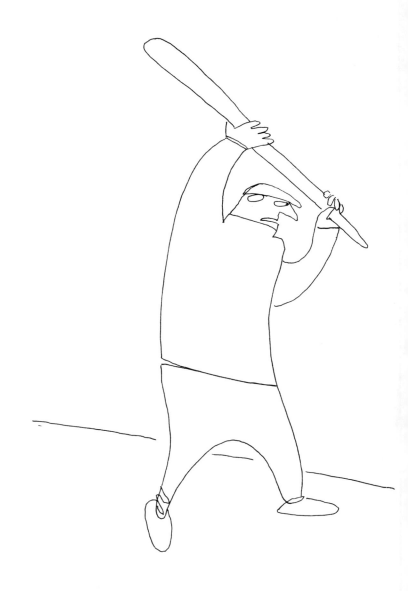

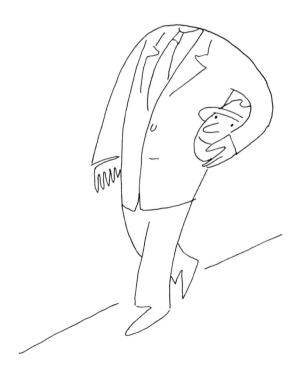

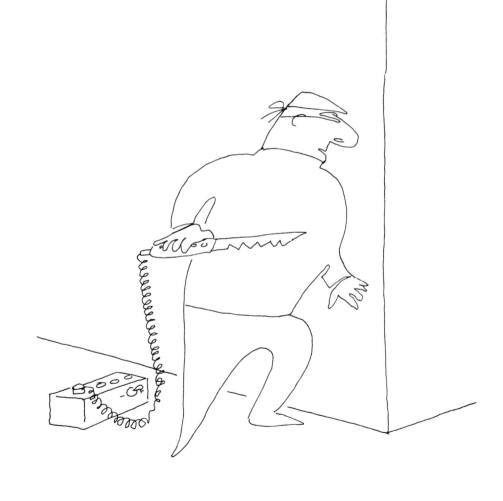

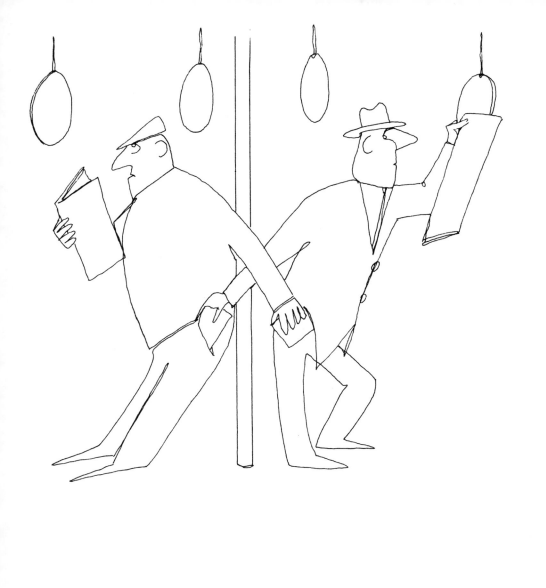

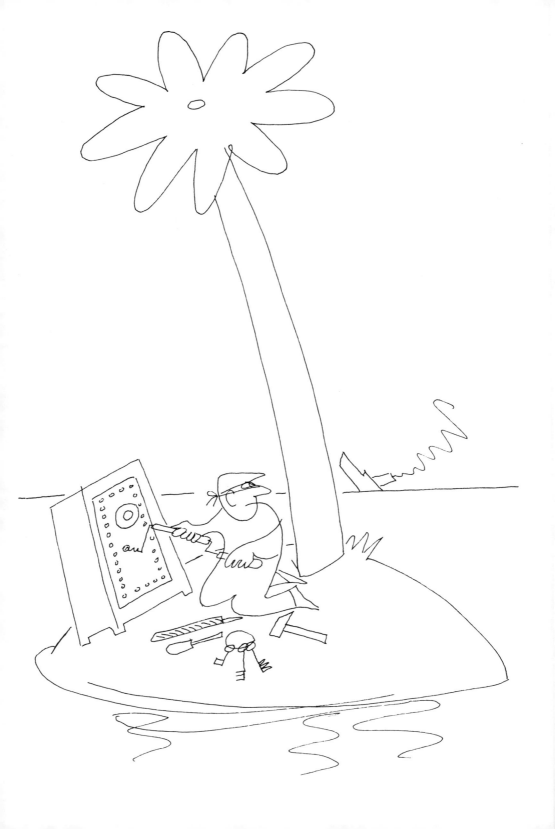

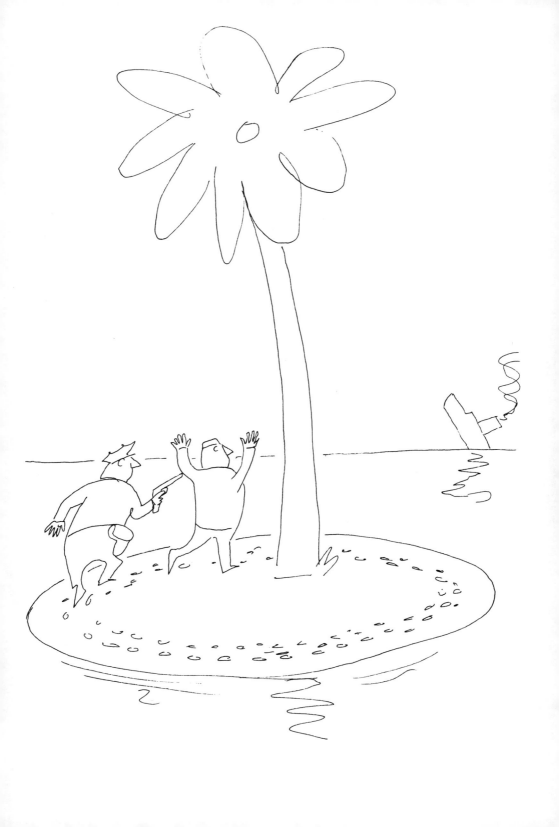

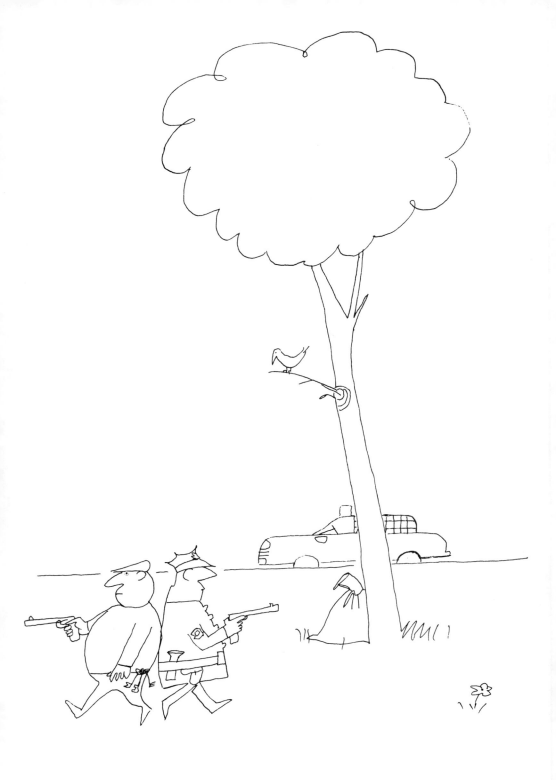

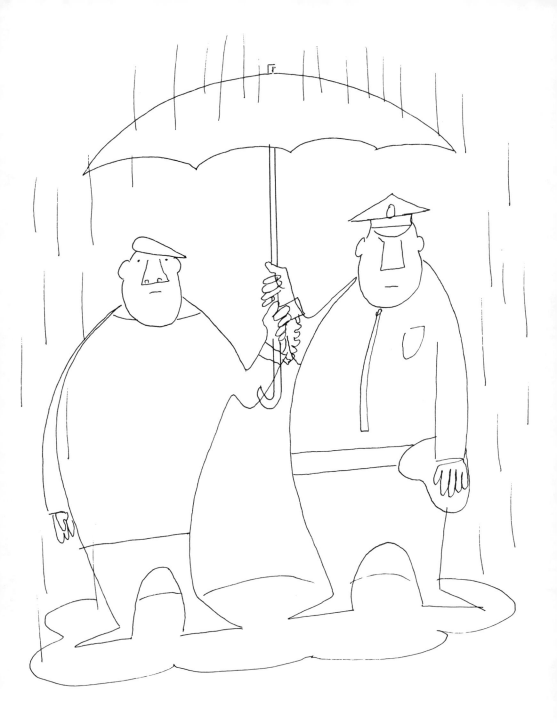

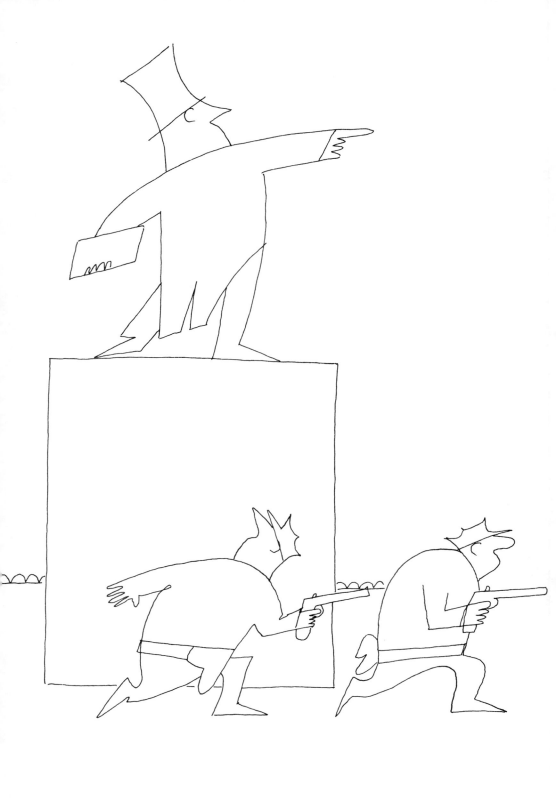

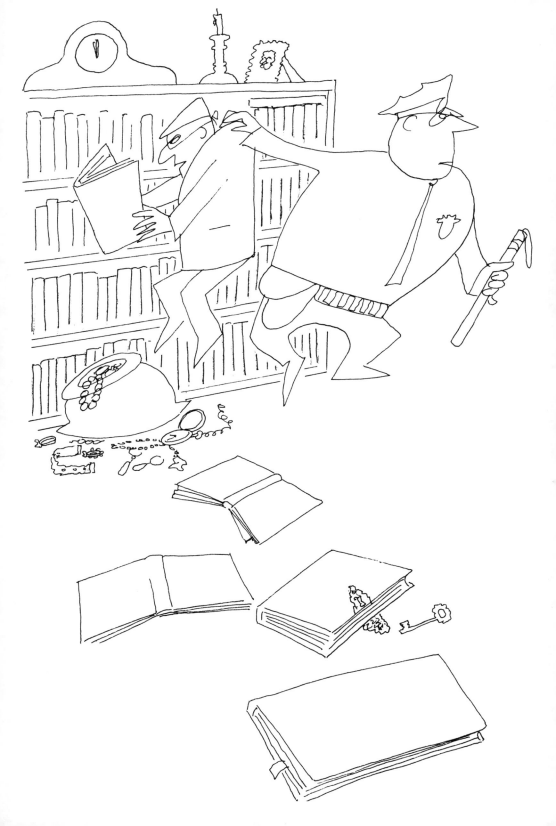

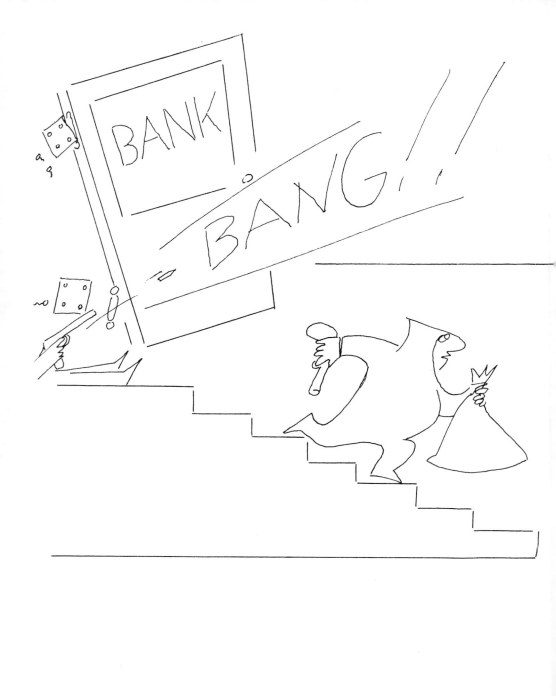

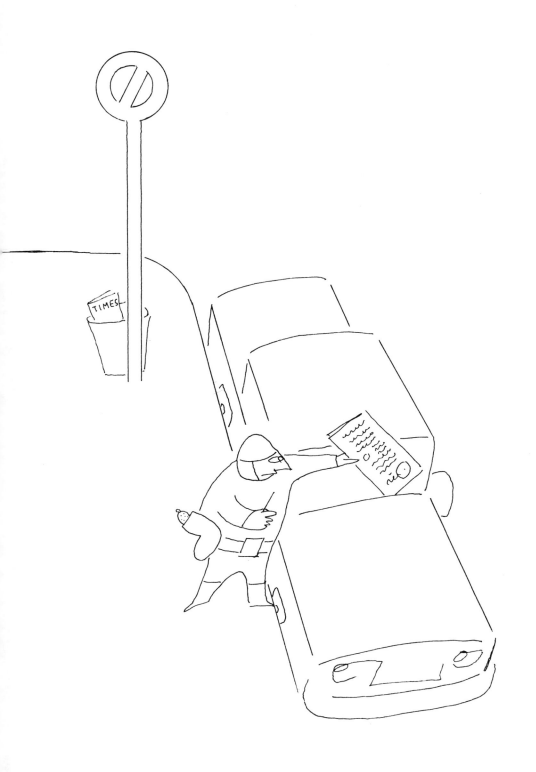

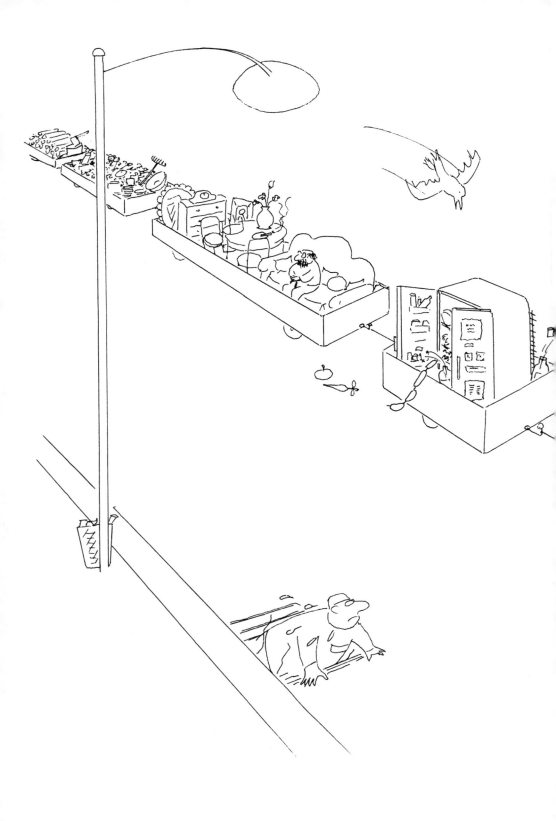

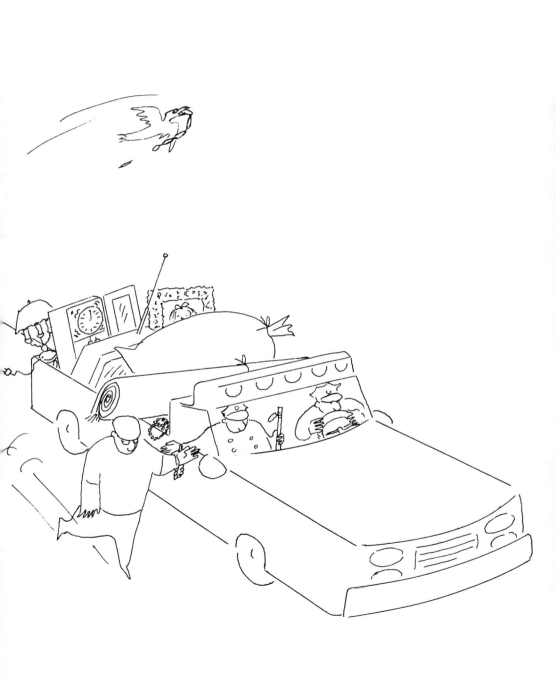

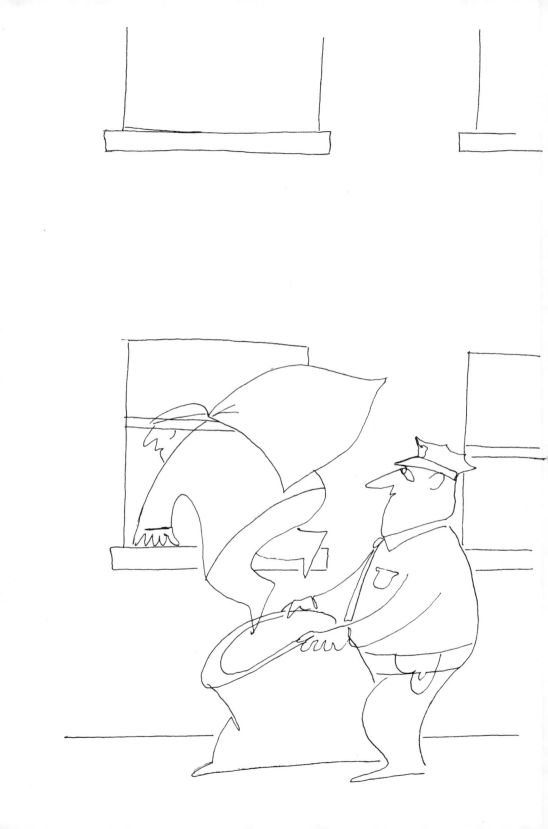

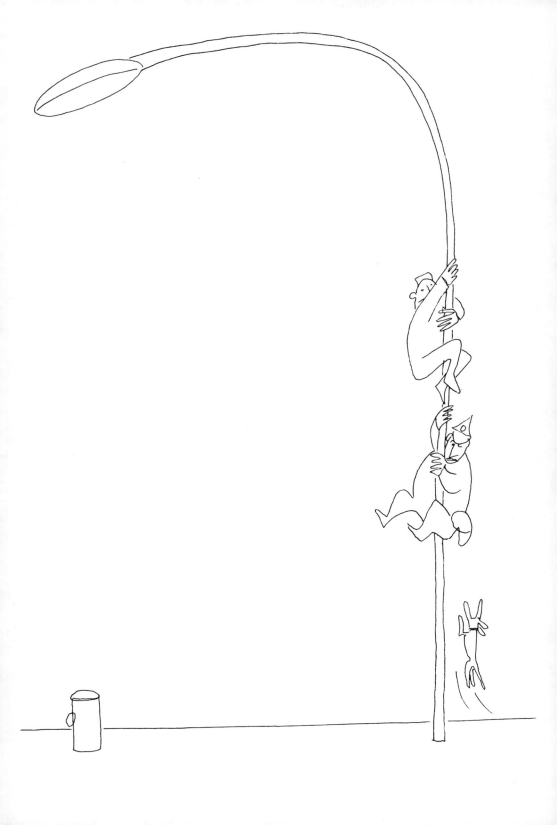

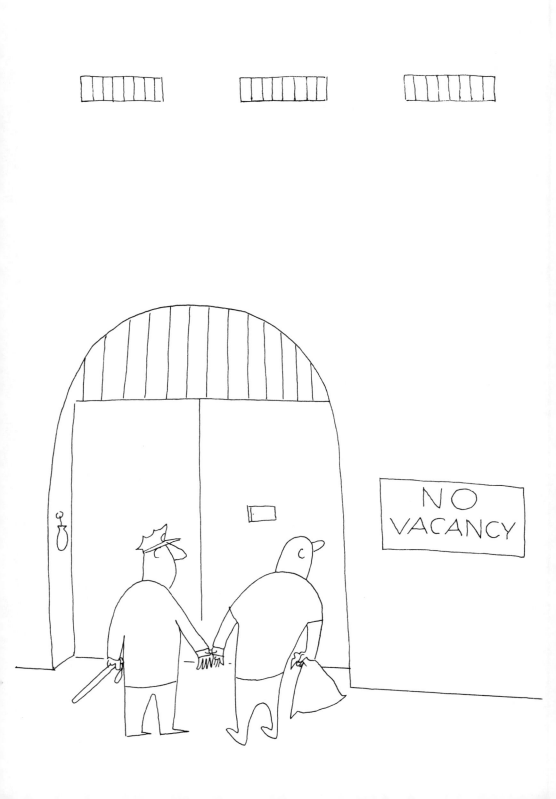

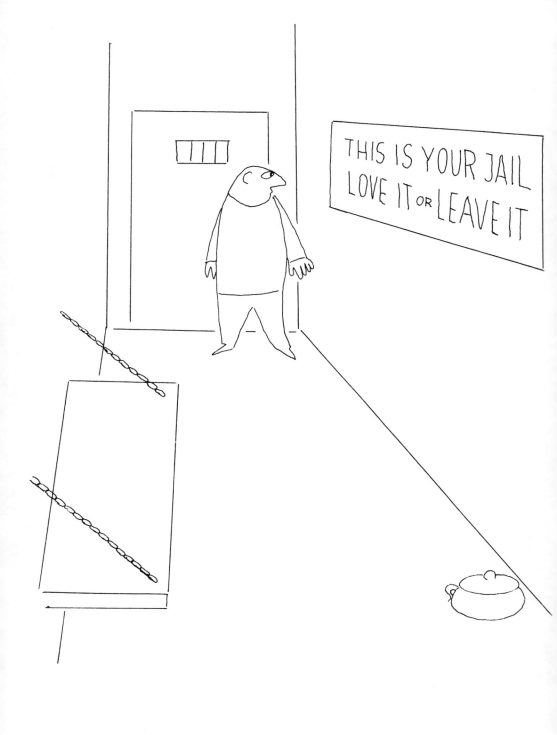

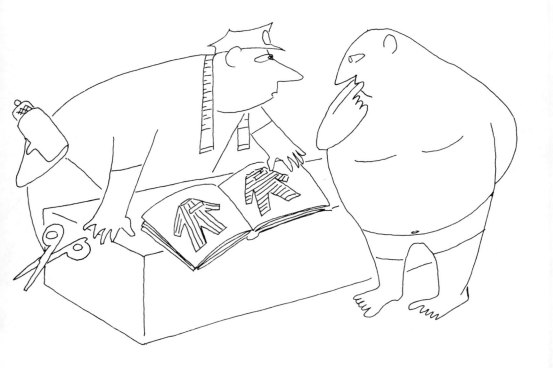

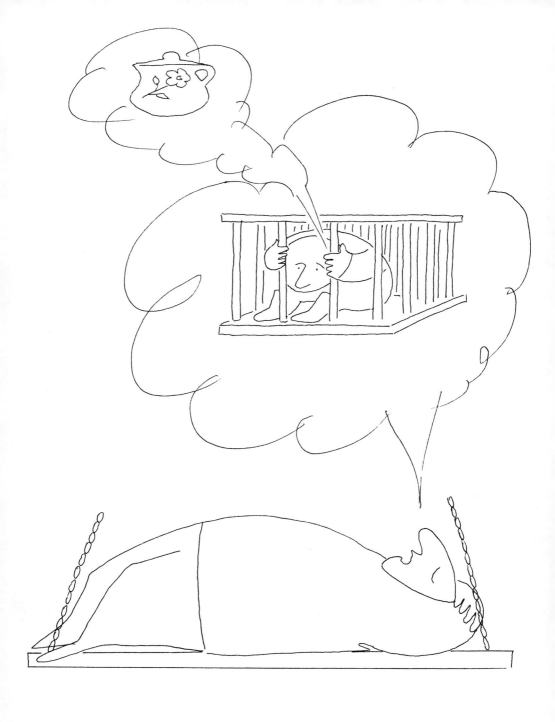

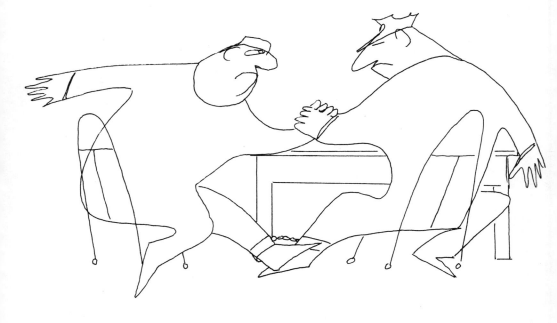

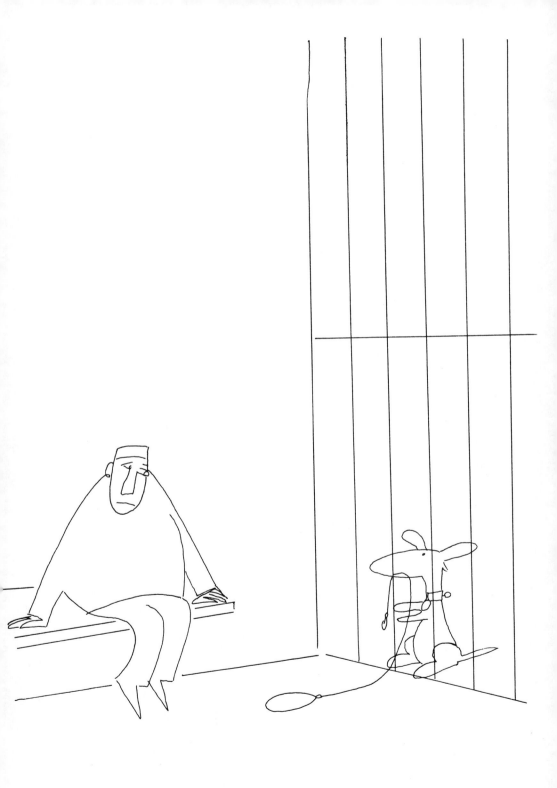

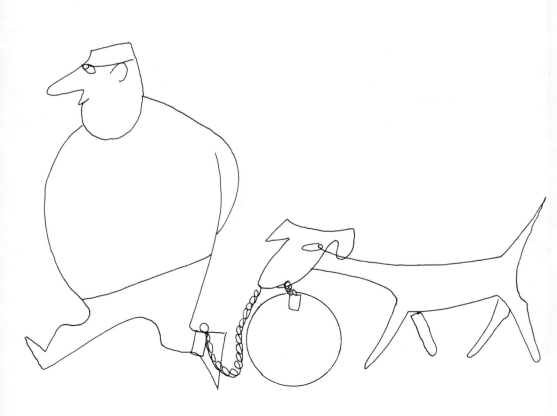

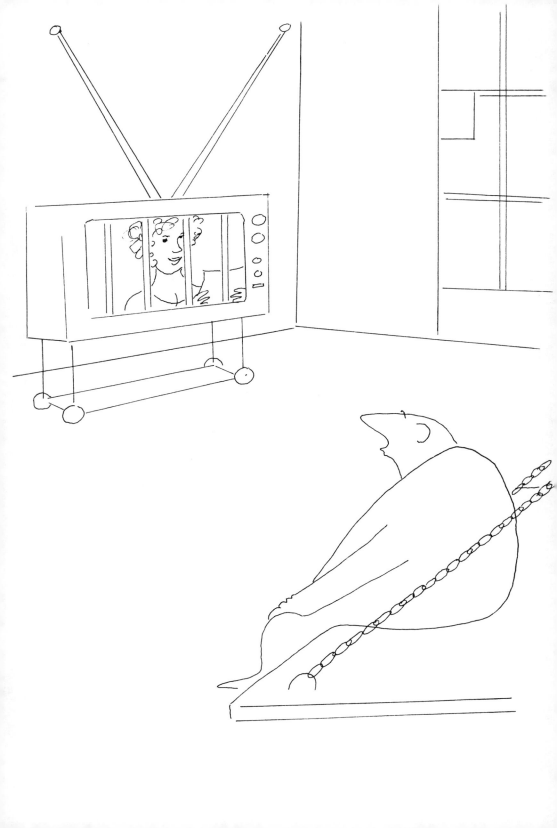

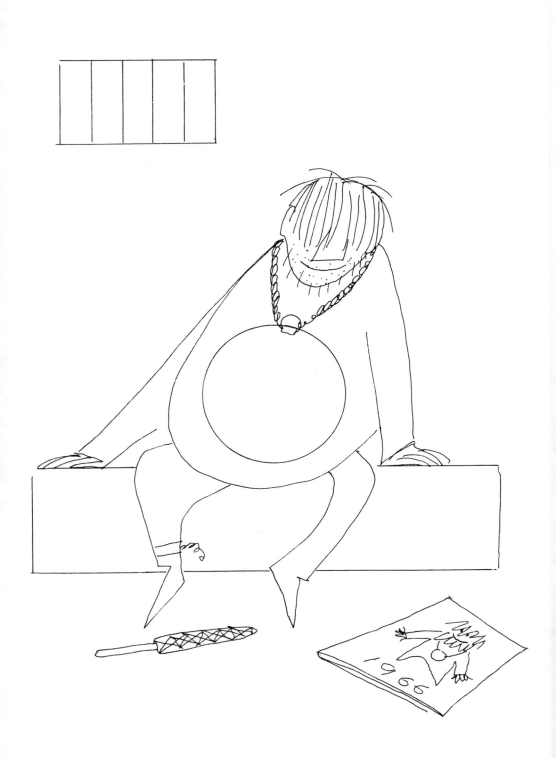

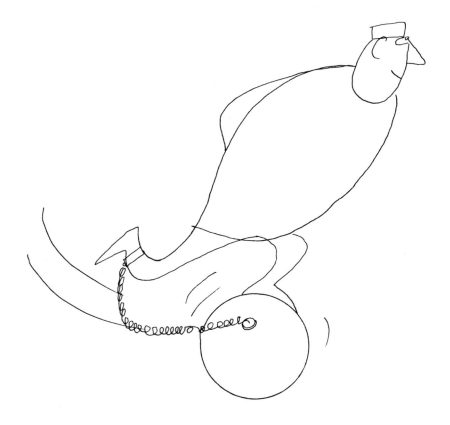

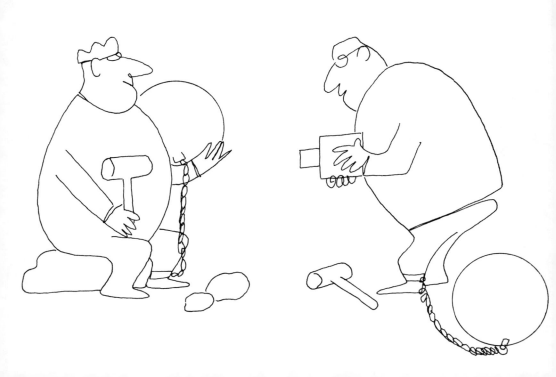

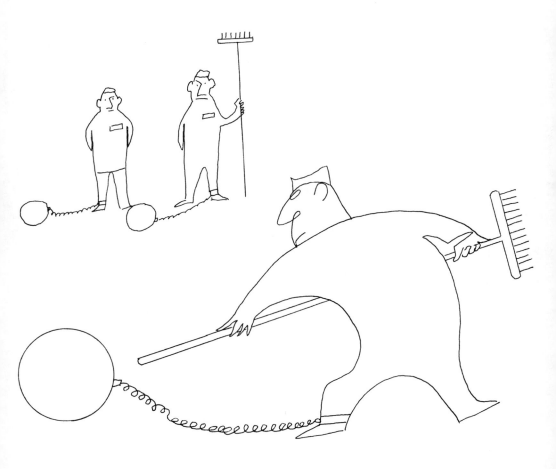

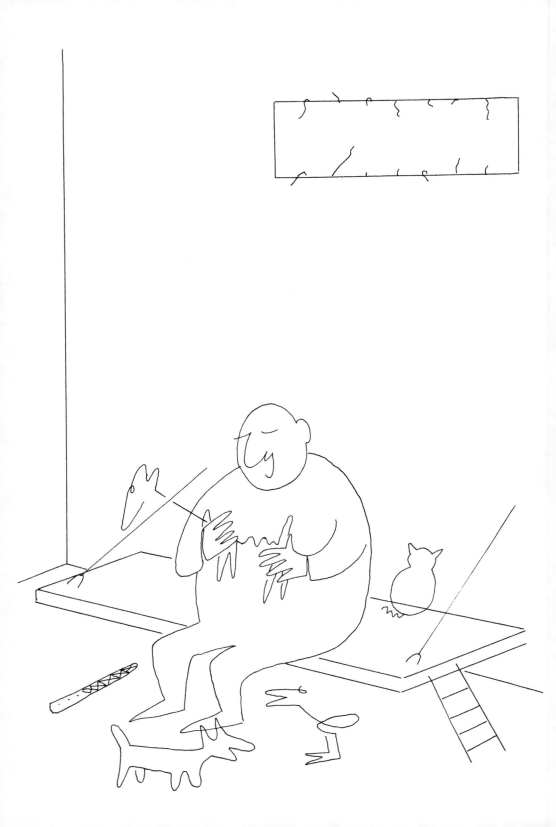

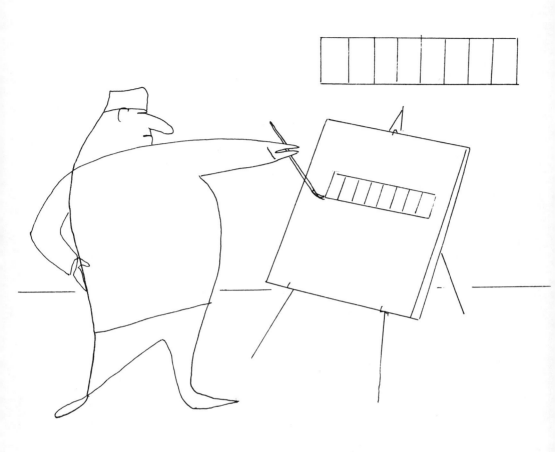

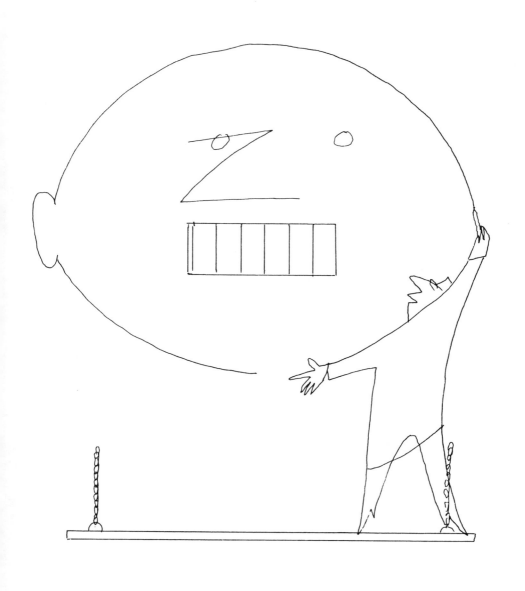

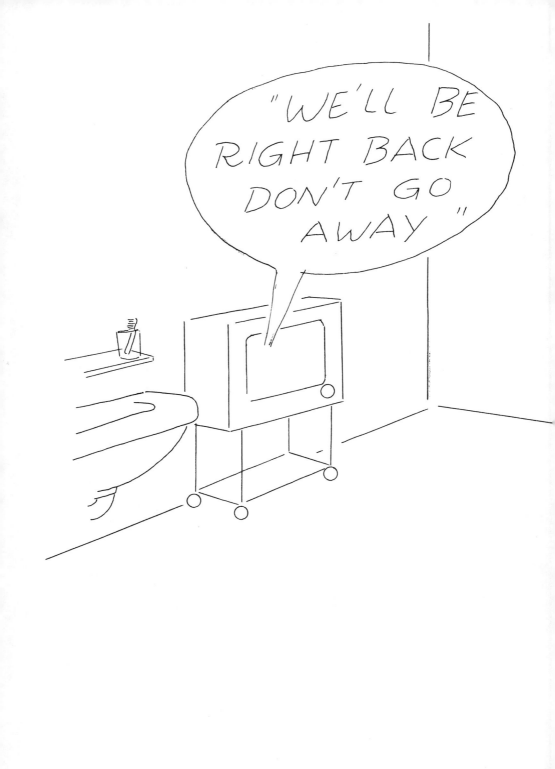

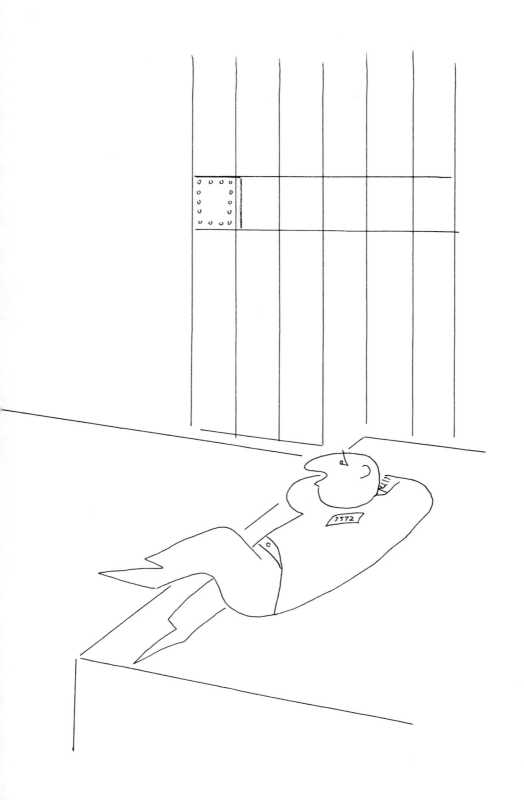

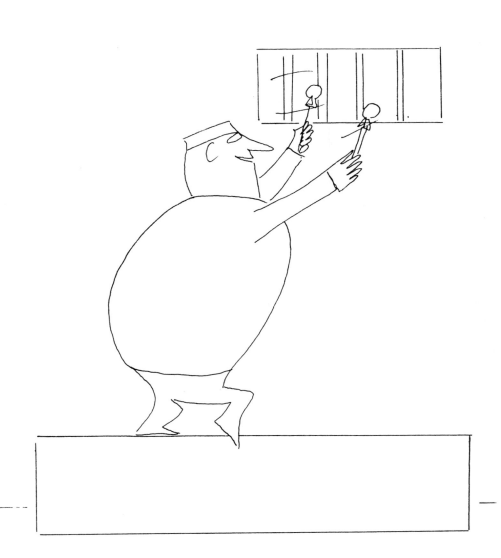

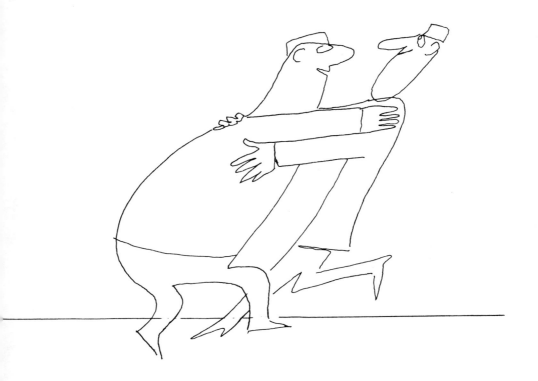

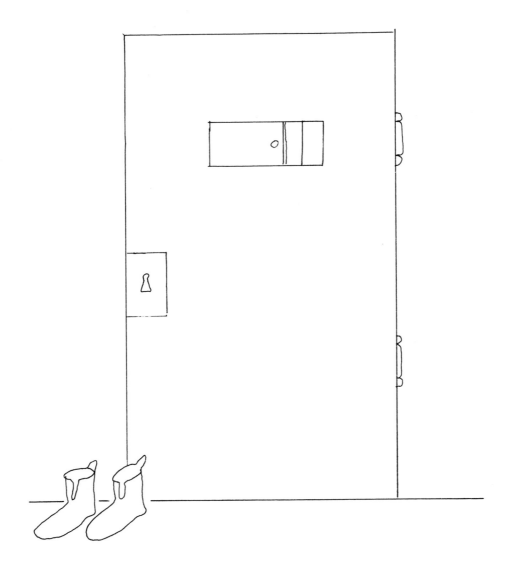

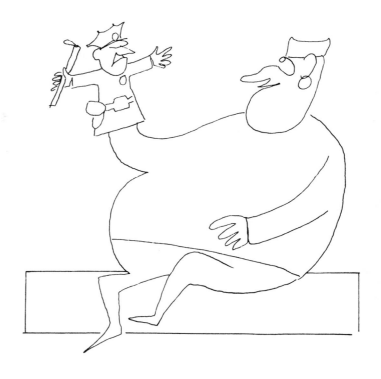

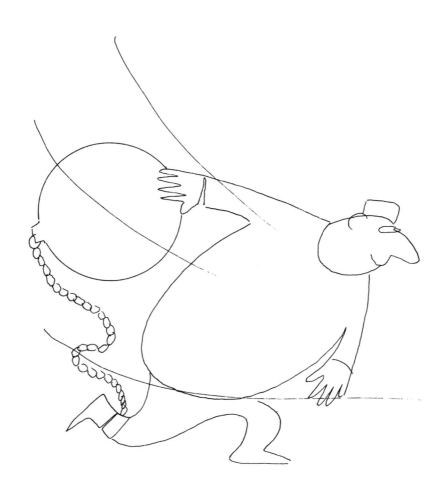

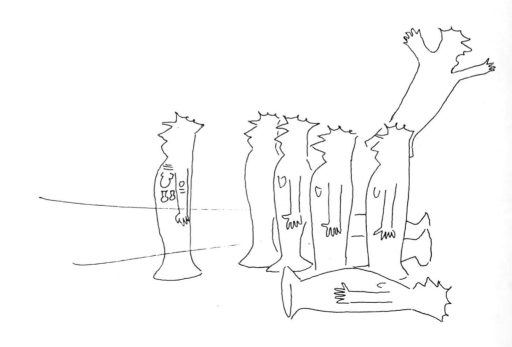

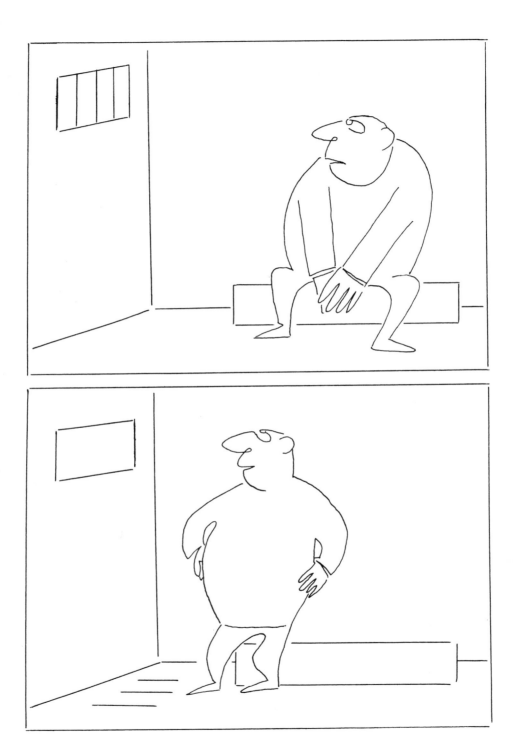

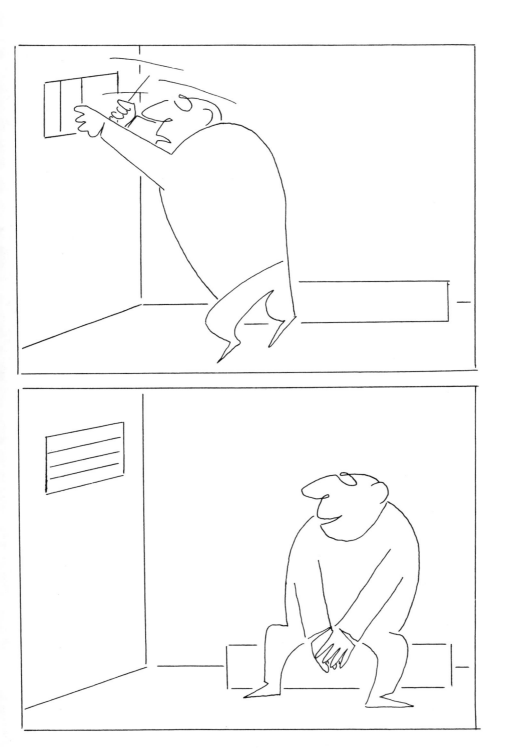

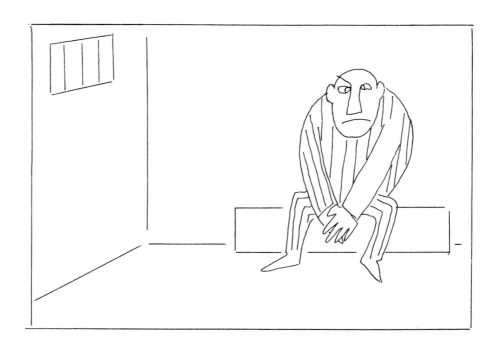

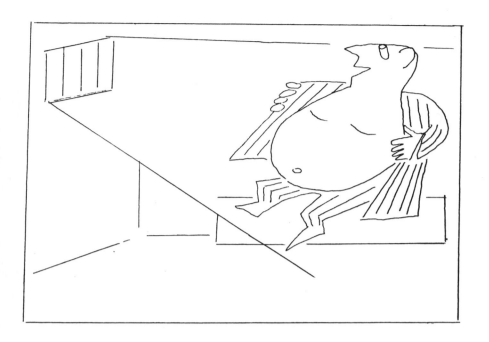

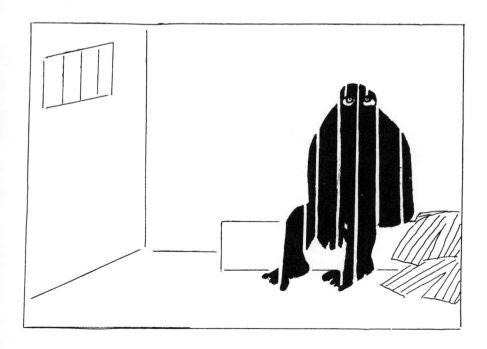

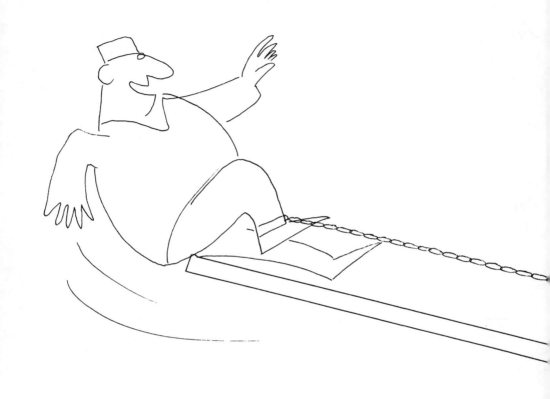

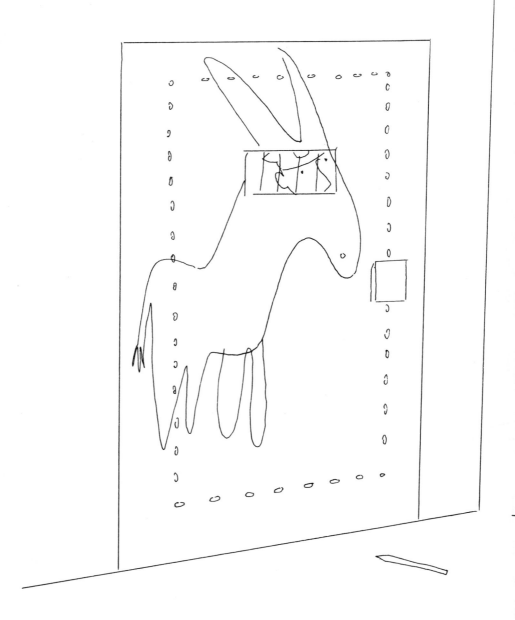

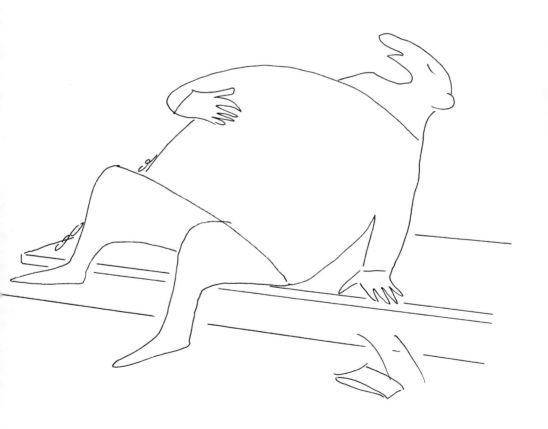

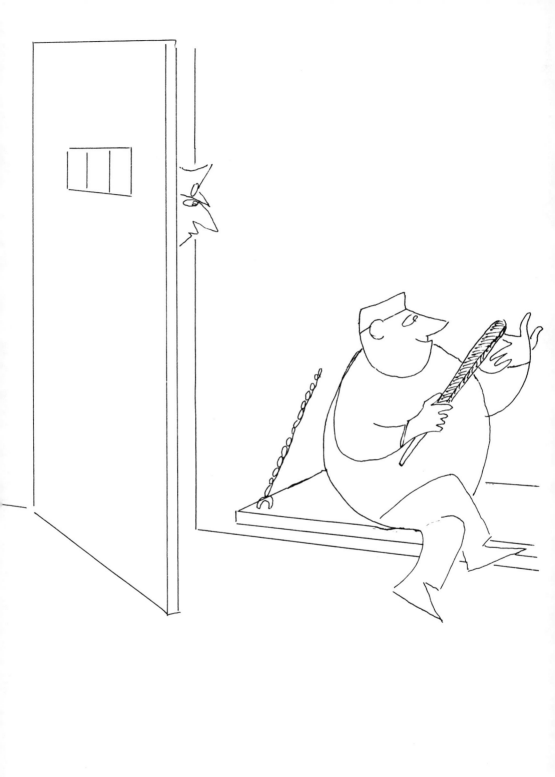

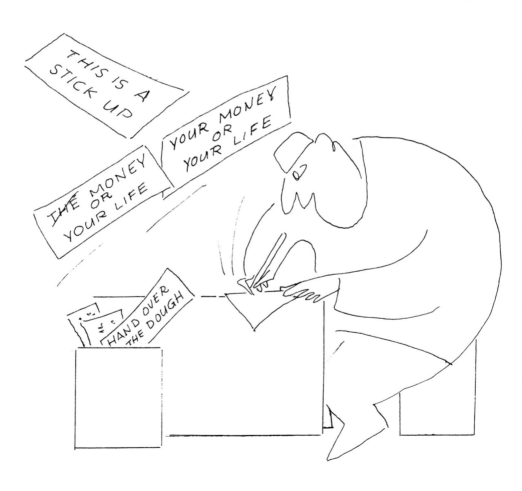

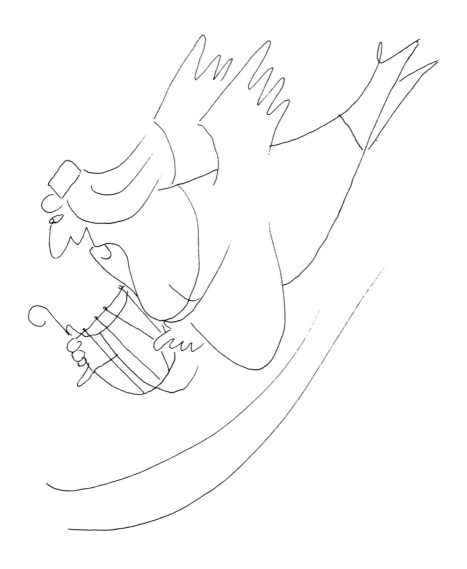

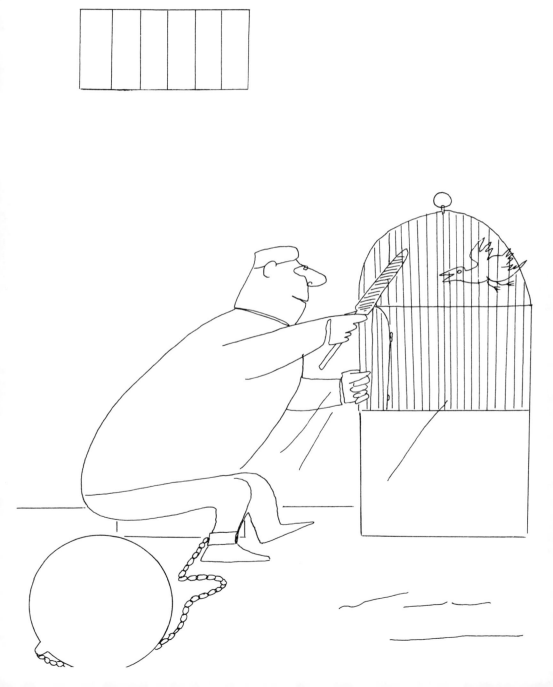

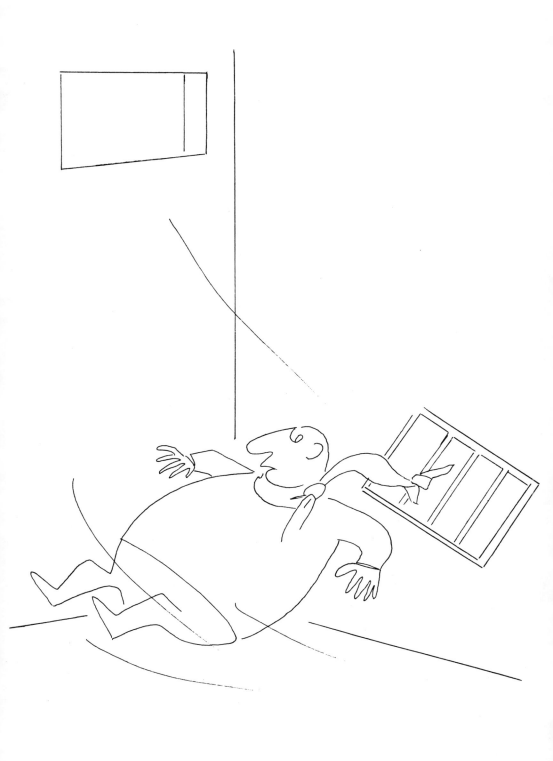

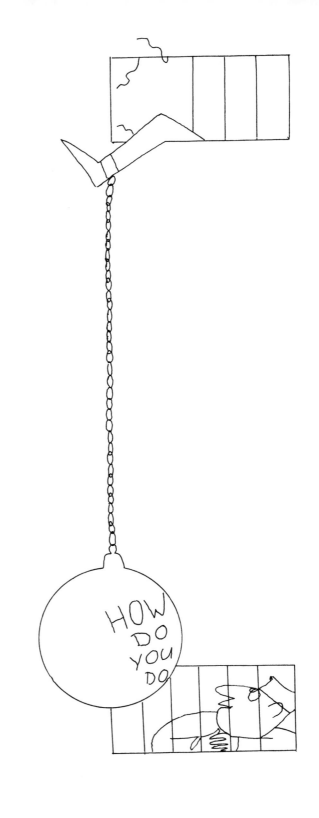

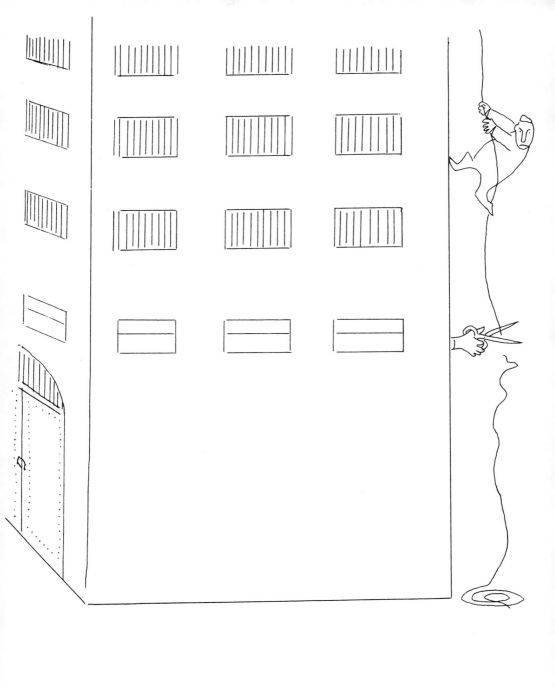

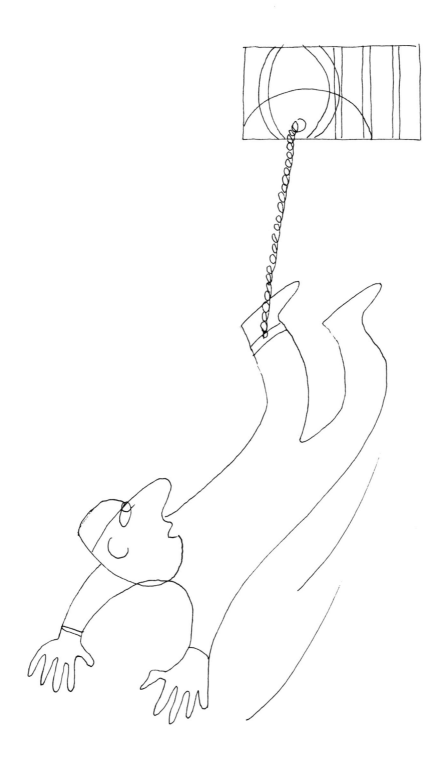

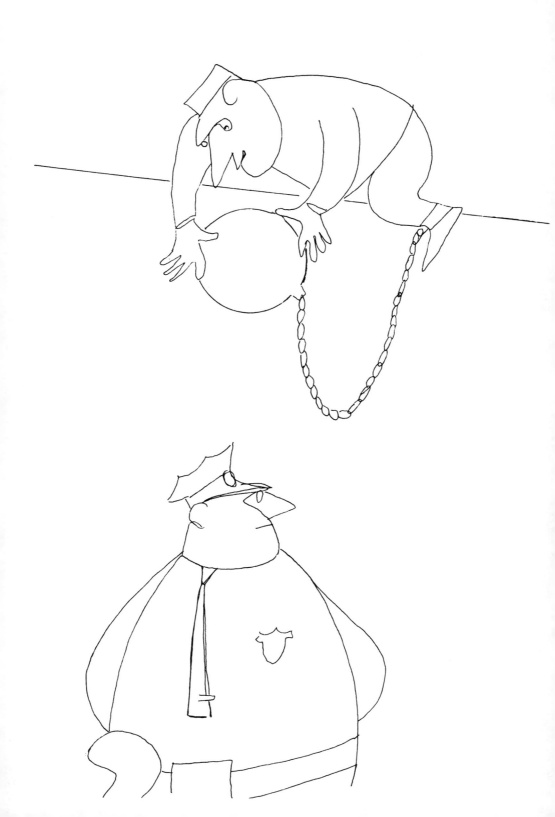

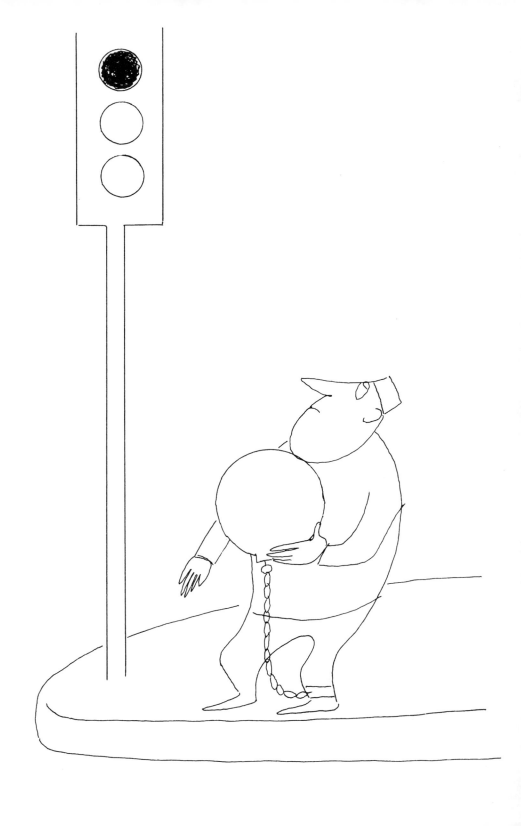

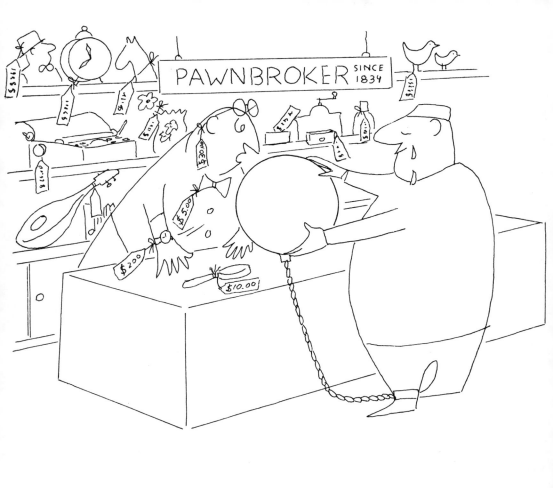

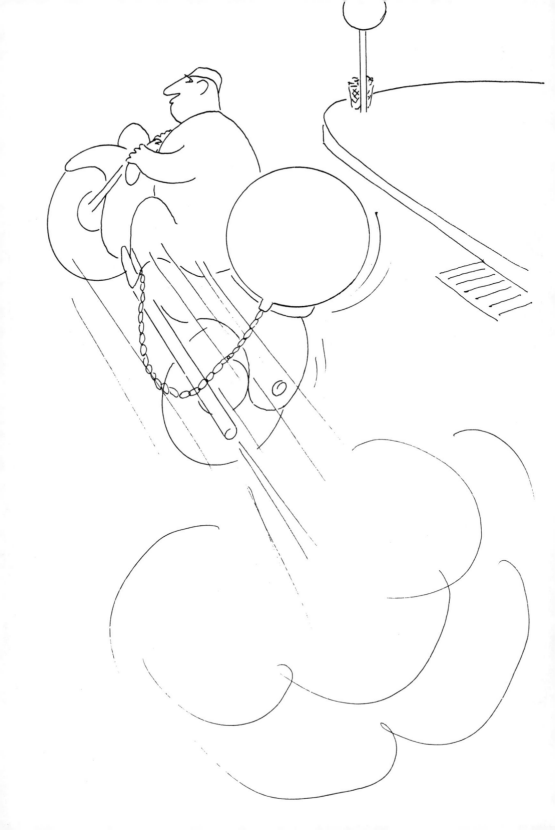

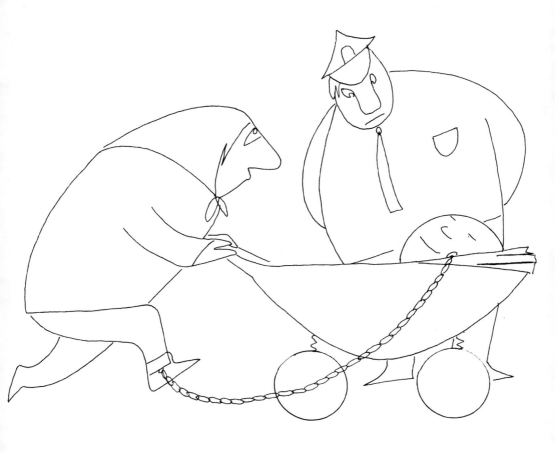

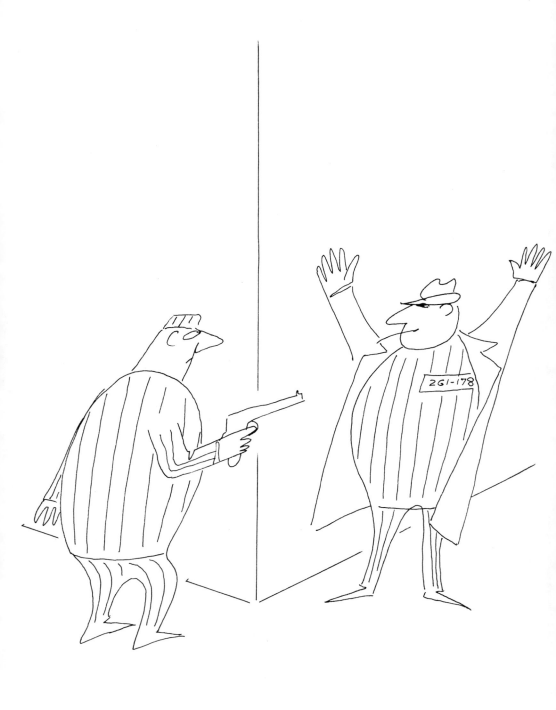

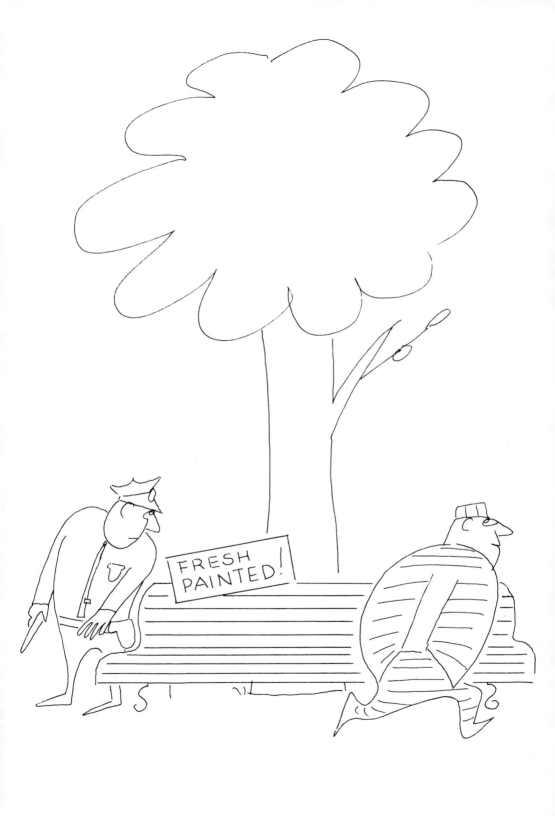

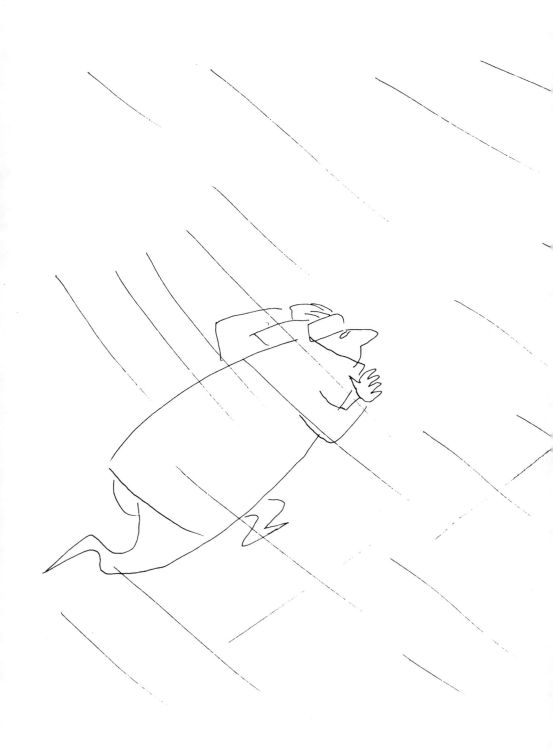

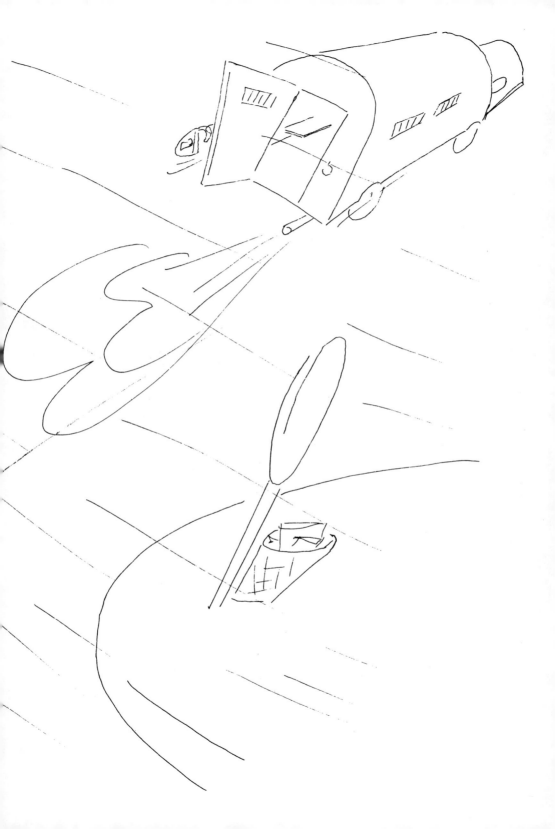

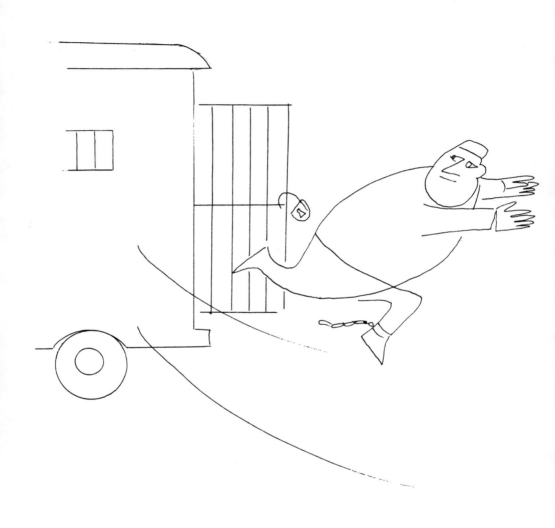

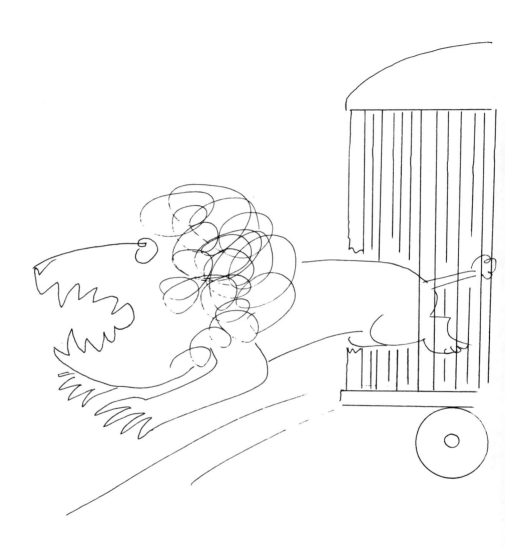

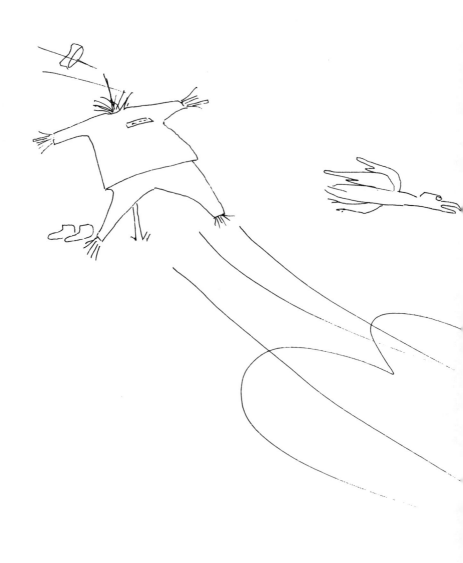

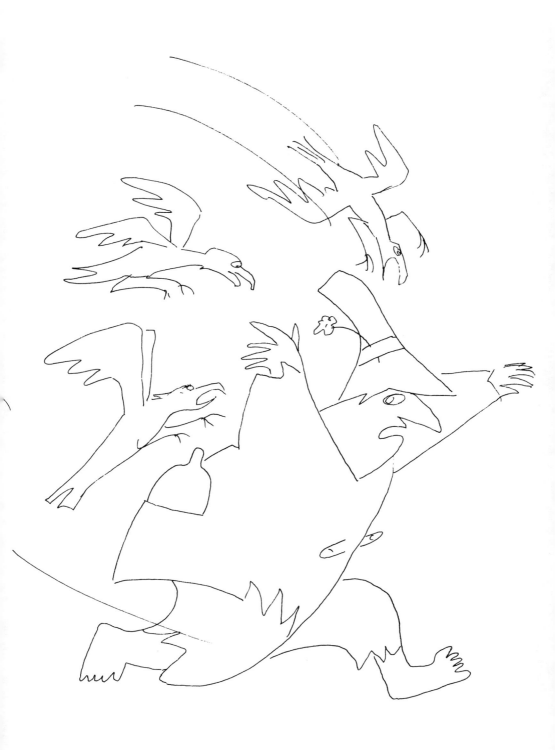

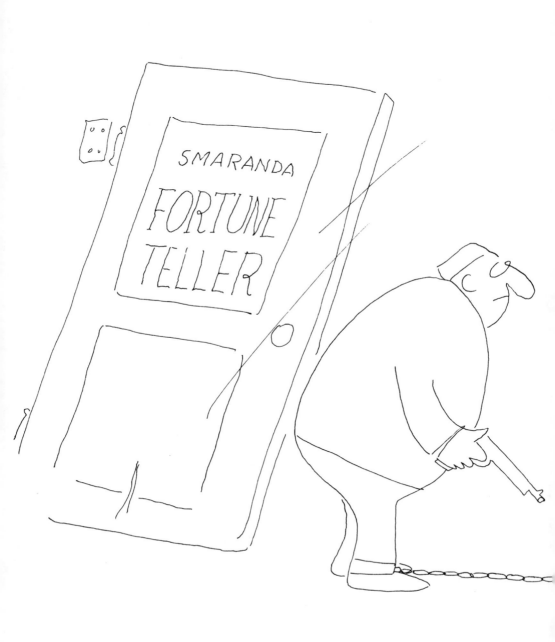

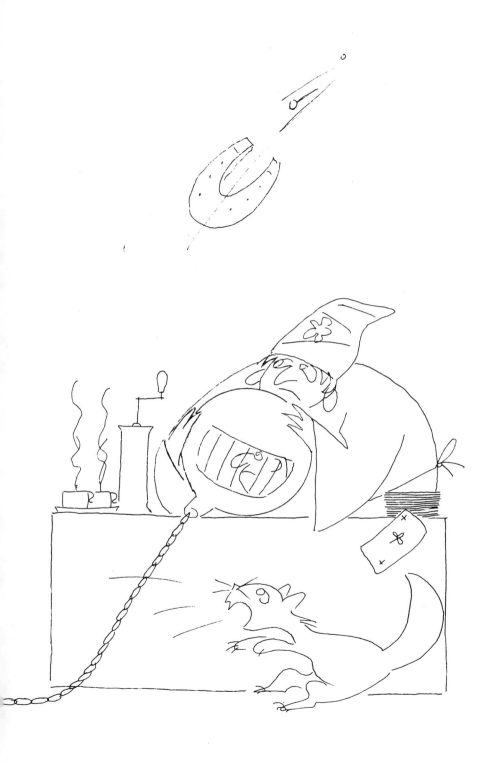

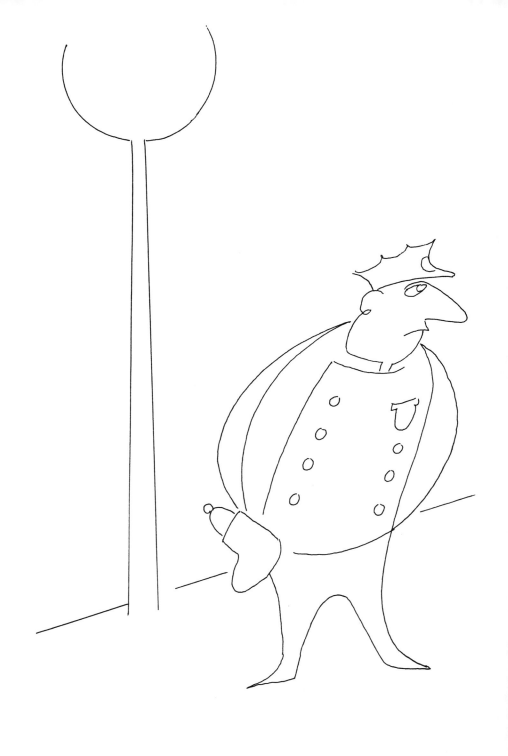

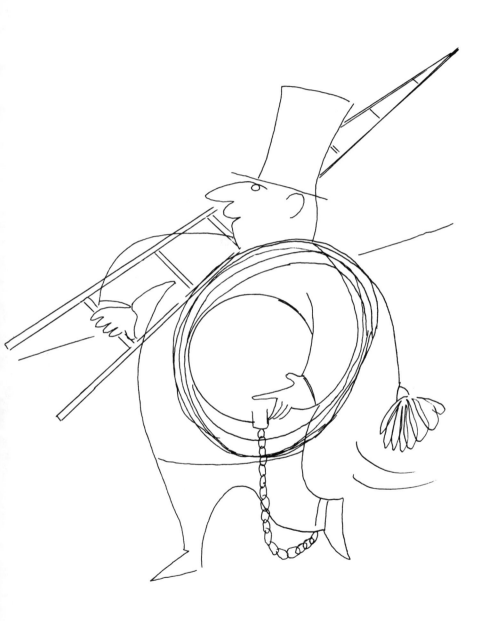

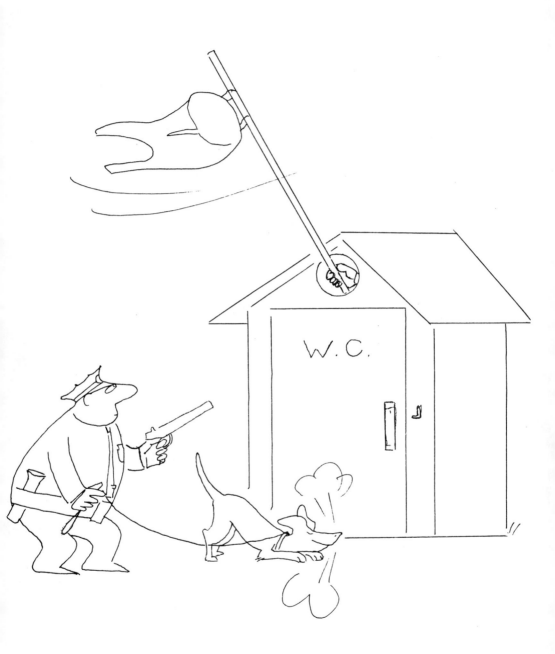

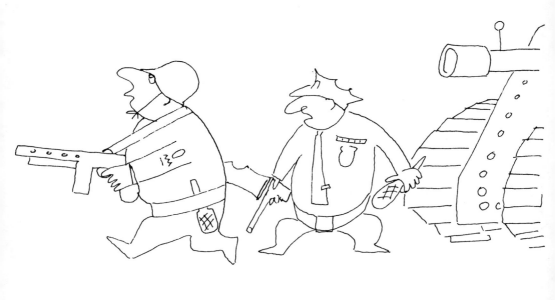

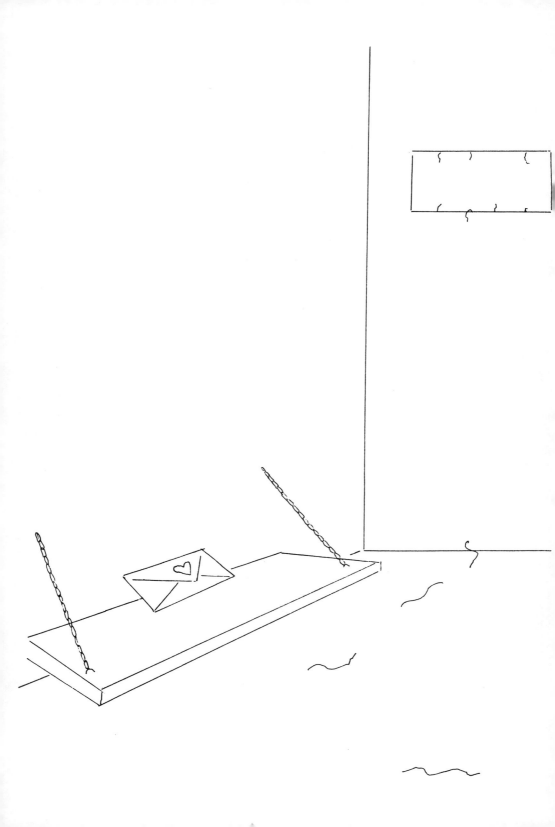

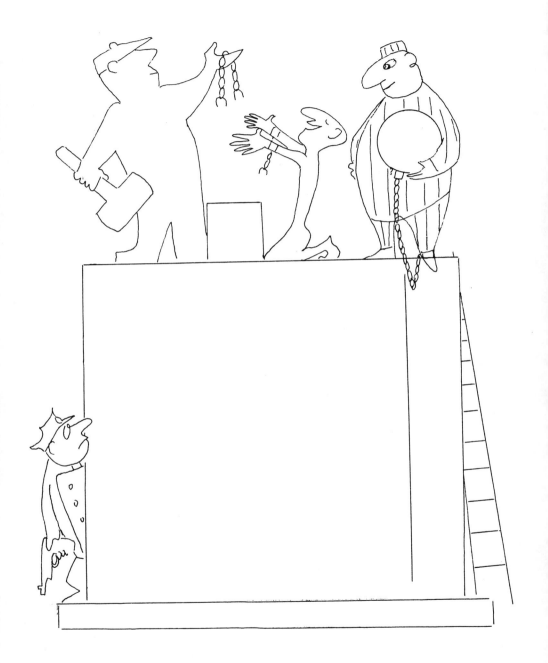

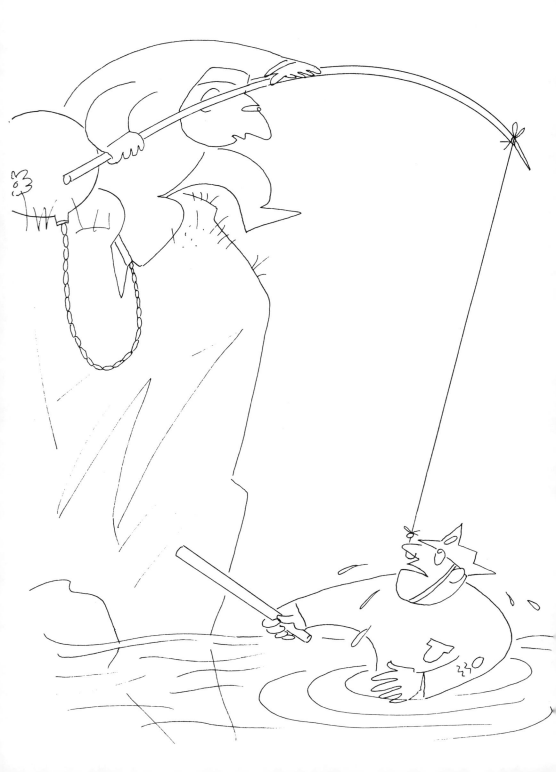

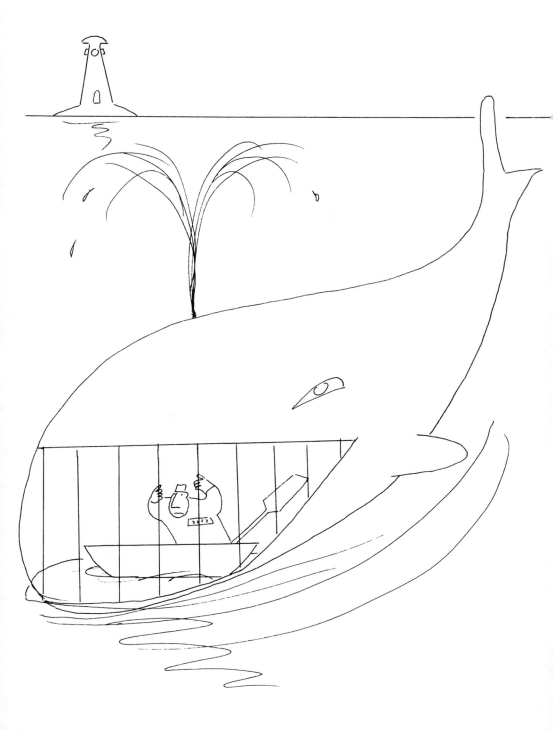

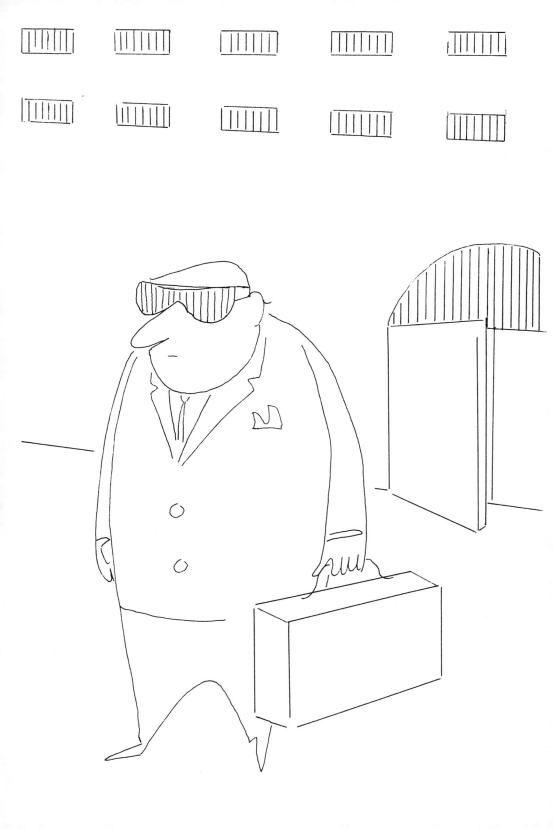

AFTERWORD

When he was three years old, Ed Arno exhibited the precocity of his genius by drawing a perfect copy of a Bayer aspirin logo sign, with traditional German gothic lettering, which he could see in the window of a pharmacy across the street from his nursery. When his mother proudly sent the drawing to her sister in America, Arno's aunt threw it away, declaring that it was impossible for a three-year-old to have drawn it.

For Arno, this was the beginning of a contrapuntal pattern of achievement and deprivation. After he completed his training in stage design at the Paul Colin Art Academy in Paris, he set about establishing a career in film animation. He had just signed a contract with the Pathe Nathan film company when Hitler's army occupied Austria. In a race to avoid the invasion of the oncoming Nazi forces, Arno abandoned his studio and all its contents, and fled from Paris to Czernowitz. This provincial city, formerly part of the Austro-Hungarian monarchy, to which Arno's family had moved from Innsbruck shortly after his birth, soon saw a revolving door of occupation by the Soviet Union, and then by the German-Rumanian army. Arno and his entire family were forced into the confines of the ghetto, and then deported to concentration camps. Arno's early work was left behind, as were all his possessions, with the exception of a few photographs of his work that he was able to retrieve at the end of World War II. After three years of near starvation and torturous labor, Arno was one of the first Holocaust survivors liberated by the Soviets in 1944.

In 1964, Arno, his parents, and his wife Rita were granted permission by the Rumanian government to emigrate. Arno was not granted permission to take with him the work he had accumulated over twenty years—years in which he had written and illustrated children's books and created posters, cartoons, and films. In 1947 he had originated a film in which, for the first time ever in Europe, live action was combined with animated drawings. This film, as well as Arno's personal collection of works of art, and the rest of his oeuvre, prodigious in its quantity and distinguished by its quality, were commandeered by the Rumanian communist govern-

ment and declared national treasures. Happily, thanks to shifts in the balance of power, some of Arno's work has since been reclaimed by his wife's family, living in Bucharest, and returned to him.

In 1964, as stateless persons with only certificates of exit, Rita and Ed flew from Rumania to Italy. Rumanian-born film director Jean Negulesco, an admirer of Arno's work, prevailed upon them to leave for New York and make their permanent home and workplace there. Traveling with Italian *stranieri* passports, the Arnos arrived in New York in 1965.

I first met Ed Arno shortly after his arrival. I was the cartoon editor for the *Saturday Evening Post*. I was stunned by the drawings he presented, the elegance and simplicity of which brought to mind the sketches of Pablo Picasso and Henri Matisse. This is not to say that his drawings appeared derivative, but rather that they were instantly recognizable as art, wonderfully conceived in the originality of his perspective and perceptions. For the sake of titular singularity—as decreed by Jim Geraghty, then arts editor of *The New Yorker*—Arno's memorable cartoons could appear in *The New Yorker* only after the death of Peter Arno (no relation) in 1969. His cartoons now, as then, please, intrigue, and quicken our minds and hearts.

In 1977, the Council of Europe selected Arno as the recipient of the SARTI Award for his Venice in Peril posters. In 1979, the Austrian Cultural Institute organized Arno's first one-man show. In 1997, the Osterreich-ische Exilbibliothek im Literaturhaus added Ed Arno's work to its archives. These works include over six hundred children's book illustrations, cartoons from *The New Yorker, The New York Times, The Harvard Business Review, The Saturday Review, Look, The Saturday Evening Post, Palm Beach Life Magazine,* and personal letters. This collection is on view in Vienna.

Charles Addams, one of the most celebrated of all *New Yorker* artists, and an artist revered by Arno, often spoke of his delight in Arno's drawings, as did constructionist artist Joseph Cornell. The French-Rumanian abstract sculptor Constantin Brancusi was one of Arno's earliest admirers, and welcomed him to his Parisian atelier. The thematic simplicity of Arno's work appealed to conductor Norbert Gingold, who composed the

music for some of Arno's European animated films. In America, pianist Arthur Rubinstein set to music two of Arno's best-known illustrated books for children, *The Magic Fish* and *The Gingerbread Man*. Both books have sold over one million copies! Ed Arno's drawings can be found in the permanent collections of The White House, the Cooper-Hewitt Museum, and the National Art Museums of Moscow and Bucharest.

Arno's own favorite creation is his "criminal," with whom he identifies. The wit and pathos of this mute image, who documents humor's conquest over tyranny, and whose actions require no caption for reinforcement, were born of the duress of Arno's imprisonment during the Holocaust years. Many of the cartoons in Arno's "criminal at large" series, done in the late 1960s, were used to illustrate crime book reviews in *The New York Times Sunday Book Review* section.

The locus of Ed Arno's widespread appeal is his genius in finding the accurate and hilarious gesture, the one perfect journey for the eye to take from line to line. His vision is a skillful amalgamation of distance, which is the privilege of a foreign observer, with the compassion that belongs to one who has endured much and survived brilliantly.

LEILA HADLEY